ARTISTS
and
THEIR CATS

ARTISTS
and
THEIR CATS

By Alison Nastasi

CHRONICLE BOOKS

SAN FRANCISCO

Page 110 constitutes a continuation of the copyright
page.

Library of Congress Cataloging-in-Publication Data
available.

ISBN: 978-1-4521-3355-3

Manufactured in China.

Design by Kristen Hewitt
Cover image by Roger Higgins

10 9 8 7 6 5 4 3 2

Chronicle Books LLC
680 Second Street
San Francisco, CA 94107
www.chroniclebooks.com

DEDICATION

For Griffin and Sascha, the greatest cats
an artist could ever hope for.

CONTENTS

INTRODUCTION

Every artist needs a muse, and every cat needs a human . . . to rule over. The universe could potentially implode if these fundamental laws were broken, which may explain why creative personalities throughout history have kept cats as companions. When considering the great artists of our time, or the artistic temperament in general, labels like "nonconformist," "aloof," and "mysterious" are often applied. The clichés are worthy of much eye-rolling, but in the case of humankind's kittenly companions, the statements ring true.

One of the animal kingdom's most independent species, the cat is essentially a solitary creature, possessing deeply ingrained territorial and predatory traits. Despite being domesticated for thousands of years, the genetic difference between a house cat and its predecessor, the African wildcat, is whisker-thin. Dear kitty may not stalk the Hoggar Mountains in search of prey anymore, but living room furniture makes a fine surrogate for the rocky Algerian regions prowled by its ancestors.

Unlike their mortal enemy, the dog—a social pack animal that loves nothing more than pleasing humans and maintains a nine-to-five schedule—felines have minimal tolerance for human agendas and the personality quirks we seek to impose upon them. Nighttime is a cat's life. There are toy mice to maul, rolls of toilet paper to reap, and invisible foes to battle in the dark while their human "owners" lie asleep (or awake, dreading the inevitable clamor of their alarm clocks).

It should come as no surprise, then, that artists have always found a great affinity for cats. What other creature would join them during intense bouts of late-night studio toil and be content to simply coexist? Numerous studies have illustrated that the behavioral characteristics of different animals, particularly dogs and cats, appeal to people with comparable personalities. Inevitably, many

artists buck notions of a stereotypical temperament, but researchers have long speculated that creative individuals share common attributes—which mirror those of cats.

In a 2010 study by the Department of Psychology at the University of Texas at Austin, researchers polled more than 4,000 volunteers who self-identified as "cat or dog people" (and included participants who stated they were both or neither). Conducting an assessment using the "Big Five" model of personality traits (measuring openness, conscientiousness, extraversion, agreeableness, and neuroticism), they concluded that the "cat people" were more neurotic, less agreeable, and more introverted than their canine-fancying counterparts, but also displayed more openness. Sound like a feline you know?

Professor of psychology Mihaly Csikszentmihalyi, the founder and co-director of the Quality of Life Research Center in Claremont, California, has spent more than thirty years studying the lifestyles and habits of creative people. A summary of the psychologist's work, excerpted from his book *Creativity: The Work and Lives of 91 Eminent People* in *Psychology Today* magazine, notes that it's not unusual for artists to plow through periods of intense work, followed by spells of idle self-reflection. Assuming such polarized lifestyles, artists can channel energies and organize their workflow in unconventional ways. It's no different with cats. Domestic felines don't need to expend energy hunting for food (we happily serve them feasts on a platter), defend themselves against predators (feisty siblings don't count), and migrate for water and shelter (or the modern equivalent: your bed, laptop, that book you're trying to read, your piles of clothes, or perhaps your head). Nonetheless, the essential genetics haven't changed. Cats in the wild sleep up to twenty hours per day, and what is usually perceived as symptomatic of lazy cat-itis in domestic kitties (who average

anywhere from twelve to twenty hours of sleep per day) is actually an instinctive calling. Clearly, the loners and rebels (and possibly the habitual nappers) of the human and animal worlds are soul mates.

The enigmatic allure of cats has fascinated artists for centuries, notably in ancient cultures, where artisans transformed cats into omnipotent idols. When civilization embraced and eventually tamed the creatures, adopting them as pets, cats also became honored as religious and folkloric symbols, woven into myth. Artifacts offer countless examples of the reverence in which the beasts were held—suggesting that spoiled cat-brats are hardly a new phenomenon. The sacred species' popularity didn't start with the Internet; it was originally conceived in antiquity, some several thousand years ago.

Cats were deeply revered in ancient Egypt, where they became symbolic figureheads of their own religious sect, embodied in the goddess figure of Bastet (Bast). Devotees numbering in the hundreds of thousands would make an annual pilgrimage to Bubastis, home of the cat cult. Upon the cherished companions' demise, cats were mourned and mummified similarly to humans. And while Egypt's cat worship tends to dominate the history books, felines had a presence in other Mediterranean cultures throughout the ages. A temple dedicated to Bastet, discovered in Alexandria in 2010 and built by Queen Berenice II, wife of King Ptolemy III Euergetes, the third ruler of the Ptolemaic dynasty of Egypt, suggests an admiration for felines among the ancient Greeks. The Romans respected the cat's sense of independence and brought the creatures to the battlefields, using their rodent-hunting proclivities to keep food supplies and leather goods free from rats. Cats were considered emissaries of the goddess Liberty, often depicted with felines curled at her feet. According to the witchcraft lore compiled in the nineteenth-century book, *Aradia, or the Gospel of the Witches*, another Roman deity, Diana, who ruled the moon and is associated with wild animals, was said to have seduced the god of light, Lucifer, by transforming herself into a cat in order to slip into his bedroom at night.

Relics from these societies demonstrated an infatuation with cats aesthetically. Depicted as a woman with the head of a cat, and sometimes in full feline form, Egyptian artisans fashioned amulets of the goddess Bastet, often with kittens, which were worn as fertility charms by women hoping to conceive. Sculptors created Bastet idols for ritual functions and protection. Tomb paintings and bas-reliefs frequently depicted cats ushering their owners into the underworld. Larger cat breeds, such as lions, figured more prominently on Greek vases, funerary stelae, and pottery. Species like the cheetah were figuratively used by artists to express status, wealth, and power—the trappings of patrons who earned (or could simply afford) their spots. It seems likely that Roman soldiers identified with the cat's predatory skills and cunning nature: Felines were depicted on shields and flags, while cat carvings adorned Roman ships. Also commonly found on mosaics and other art objects from the ancient period, it's clear that our appreciation of cats, and the creation of artifacts to celebrate them, stretches back to the dawn of civilization.

The enduring cult of the cat eventually fell into decline. The creatures were demonized during the Middle Ages due to a sullying association with witchcraft and paganism. It would take hundreds of years for the public's perception of cats to change, but the ostracized animals would ultimately meet with a shift in attitudes that restored their lustrous repute. Once again welcomed into homes as pets, mousers, and muses, cats have become one of the most frequently depicted creatures in modern art. It's a fitting celebration of an inspiring species, which has provided loving companionship to generations of artists throughout the centuries.

AGNÈS VARDA

We're greeted by the curious gaze of a cat in the opening of Agnès Varda's intimate documentary *The Gleaners and I*. The director's beloved kitty Zgougou (pictured) affectionately rubs against her gorgeous collection of encyclopedias—a burgundy, seven-volume set of the *Nouveau Larousse illustré*—as Varda defines the word "gleaner" (traditionally, one who gathers the crops left behind after the harvest). The film evolves into a personal and poetic essay about collecting and discarding—for sustenance, conscience, and curiosity—and the inclusion of scavengers, such as cats, reminds us that there are gleaners all around us. Cats, especially her own, have always featured prominently in Varda's visual art and movies as personal symbols and witnesses. The "Mother of French New Wave" even used an illustration of Zgougou for the logo of her production company, Ciné-Tamaris. When Zgougou passed away, Varda honored her with a video installation created in 2006, *Le tombeau de Zgougou (Zgougou's Grave)*.

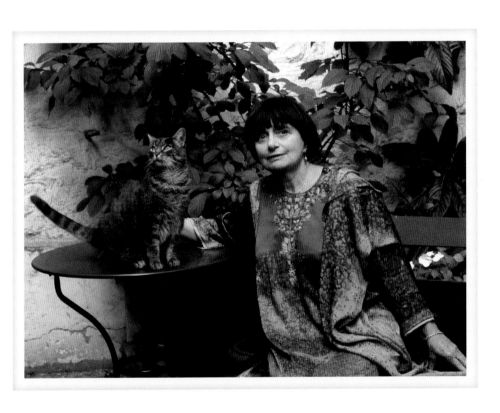

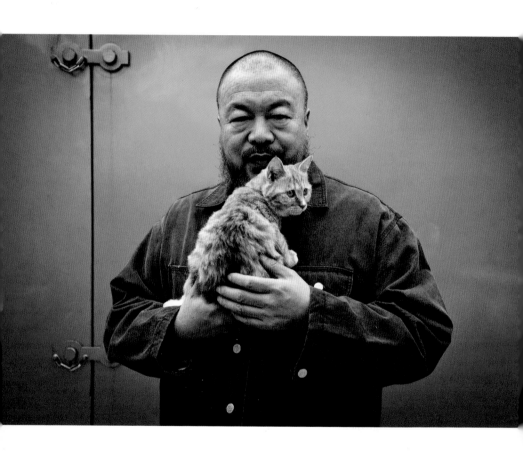

AI WEIWEI

Controversial contemporary artist Ai Weiwei's studio in Beijing, which he designed himself, is home to more than forty cats. We meet several of them in Alison Klayman's 2012 documentary about the artist, *Ai Weiwei: Never Sorry*. He tells us that one of the kitties has learned how to open doors. It's a fine metaphor for the liberating possibilities his pioneering works suggest. Despite continuing struggles against censorship (at one point being held in secret detention for eighty-one days, owing to his criticism of the Chinese government's stance on human rights and democracy), the artist's cats seem to offer him some solace. Ai Weiwei's social media accounts are frequently updated with photos of his cats, and in 2006, the artist revealed more about his connection to these favored companions in one of his prolific blog posts:

> The cats and dogs in my home enjoy a high status; they seem more like the lords of the manor than I do. The poses they strike in the courtyard often inspire more joy in me than the house itself. Their self-important positions seem to be saying, "This is my territory," and that makes me happy. However, I've never designed a special space for them. I can't think like an animal, which is part of the reason why I respect them; it's impossible for me to enter into their realm. All I can do is open the entire home to them, observe, and at last discover that they actually like it here or there. They're impossible to predict.

ALBERT DUBOUT

French illustrator Albert Dubout was known for his satirical cartoons, many of which are cat-themed and based on the humorous exploits of his own pets (including one of his favorites named Kikou). The Dubout kitties are depicted as cheeky, playful, and utterly feline. His fine line drawings capture the sophistication cats exude, even when they're being naughty.

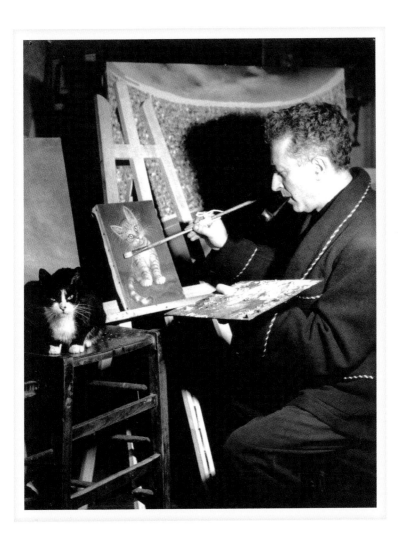

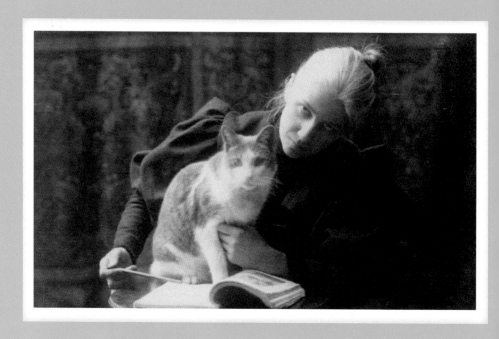

AMELIA VAN BUREN

"I early recognized her as a very capable person," Thomas Eakins, American
painter and instructor at the Pennsylvania Academy of the Fine Arts, wrote
of his student Amelia Van Buren in 1886. "She had a temperament sensitive to
color and form, was grave, earnest, thoughtful, and industrious. She soon sur-
passed her fellows, and I marked her as one I ought to help in every way...." Van
Buren arrived at the prestigious institution having already exhibited her work
throughout Detroit. Eakins subsequently tutored her, employing, it's rumored,
some rather unorthodox methods, which may have involved disrobing during
class for a brief anatomy lesson. He later asked her to model for one of his most
accomplished works, *Miss Amelia Van Buren* (1891). Van Buren opened a studio
and art gallery in New Jersey after graduation and eventually turned to photog-
raphy, specializing in portraits. Eakins surrounded himself with a menagerie of
pets, including cats—which could explain the presence of the photogenic feline
in this image of Van Buren—but he also studied them for anatomy purposes.

ANDY WARHOL

Pop art icon Andy Warhol was a collector of objects (furniture, jewelry, fine art, and kitsch items such as cookie jars); ideas, many detailed in his 1975 book *The Philosophy of Andy Warhol (From A to B & Back Again)*; and muses, who thronged to his New York City studio, the Factory. He was also crazy about cats. Warhol's passion for animals was something he shared with his mother, Julia. At one time, the artist owned as many as twenty-five cats in his Upper East Side townhouse. Warhol's nephew, the author and illustrator James Warhola (Andy dropped the "a" from his surname early in his career), told the story of those feline friends in his book, *Uncle Andy's Cats*. The tale reveals that *Sunset Boulevard* actress Gloria Swanson gave Andy a Siamese kitten named Hester. She was paired with a male cat named Sam. They had several litters of kittens, which were all named . . . Sam. The cats became the eponymous stars of Warhol's 1954 self-published book, *25 Cats Name Sam and One Blue Pussy*. Note: that's not a typo in the title. Warhol's mom rendered the calligraphy for this collection of colorful, whimsical lithographs and accidentally left the "d" off "Name." Warhol was charmed by the error and kept it. Julia collaborated with her famous son on a second book about cats in 1957, *Holy Cats*, featuring—you guessed it—cats and angels. Andy's feline creations reveal a much more personal side of the artist than all the Brillo boxes in the world.

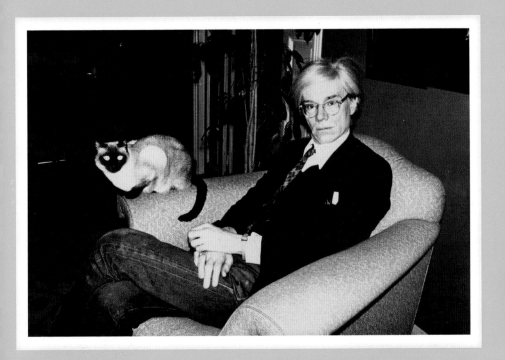

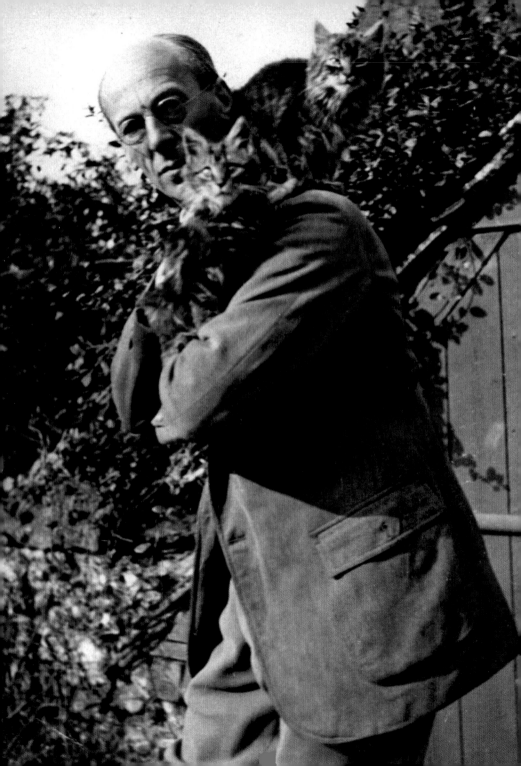

ARTHUR RACKHAM

The illustrated cats of Arthur Rackham are vivacious creations, effusive with
personality and mystique. One celebrated example, the grinning image of
the artist's Cheshire Cat from his *Alice's Adventures in Wonderland* series, is
universally beloved. Like his graceful artworks, Rackham cuts a fine figure
of Edwardian-era elegance, but he was never so dapper that he'd deny a few
feline friends the opportunity to perch on his shoulder.

BALTHUS

Known for his provocative paintings of nubile girls, French painter Balthus (Balthasar Klossowski) often included cats in his artworks. The enigmatic, knowing familiars add further tension to his erotically charged images. When the artist was only eleven years old, he befriended a stray cat named Mitsou, but their tender relationship ended when the feline disappeared. Young Balthus created a series of forty pen-and-ink drawings detailing their adventures and his devastation, which enchanted his mother's lover—the poet Rainer Maria Rilke (who gave the young artist his nom de guerre). Rilke arranged for their publication in a book named after the cat and even wrote the preface. Balthus's early drawings reveal an ability, expressiveness, and emotionality wise beyond his years. After his debut exhibition in Paris, cats became the center of Balthus's work again. His 1935 self-portrait, *The King of Cats*, shows the slender artist towering over an affectionate kitty that appears at once dazed and steely-eyed. Another reflexive study, the 1949 painting *The Cat of La Méditerranée*, transforms the artist into a sinister cat preparing to feast on a plate of fish. Balthus welcomed many cats to his Rossinière chalet until his death in 2001.

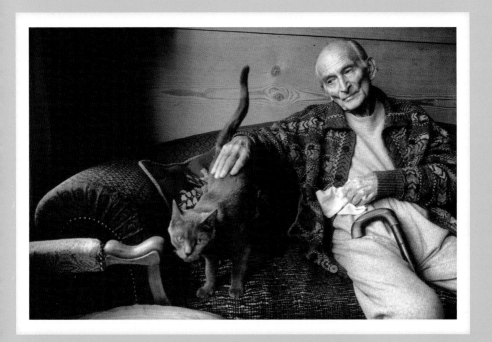

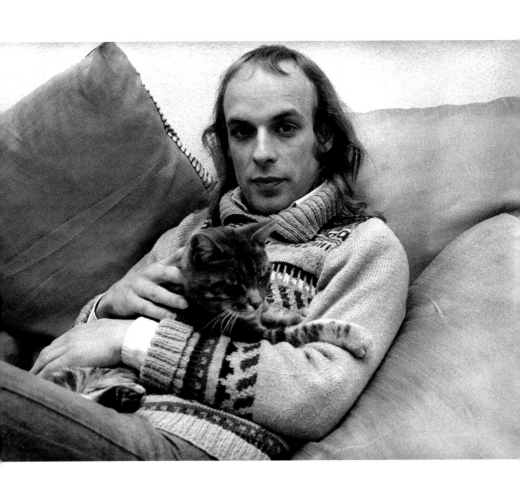

BRIAN ENO

Perhaps best known for his lush ambient soundscapes, pioneering English musician Brian Eno began his creative career as a painter. Studying the radical Groundcourse (an experimental art program led by acclaimed professor Roy Ascott) at Ipswich Civic College early in life, Eno's artistic abilities were later evidenced by his innovative light and sound installations—one of which illuminated the Sydney Opera House. Uniting his passions, Eno created a visual and sonic app for the iPad, called Scape, that allows users to experiment with textures of sound and shape. He also designed a healing light and sound installation for hospitals. The artist's meditative sensibilities seem to extend to his love for cats as well, as this 1974 photo illustrates. Eno cat pics are an Internet favorite, and one of the artist's very photogenic kitties can be found in the 2011 film *The British Guide to Showing Off,* which documents the celebrated, anarchic Alternative Miss World costume pageant organized by artist Andrew Logan.

CLAUDE CAHUN

Born Lucy Schwob, Claude Cahun was the niece of distinguished symbolist writer Marcel Schwob. She adopted the androgynous moniker in her twenties— an act that fueled her intimate, staged self-portraits, which blurred the lines of gender and identity. She arrived in Paris during the 1920s with her lifelong partner (and stepsister), Suzanne Malherbe. Cahun was a radical and active figure among the surrealists, though she rejected all labels, and later became a resistance fighter during the Second World War. This led to the creation of fake documents, which disguised the covert missions she undertook (akin to performance art) against the occupying forces in France. These stunts found her and Malherbe arrested and sentenced to death in 1944, but the artists were later released. Cahun, a tremendous cat lover, continued to challenge notions of identity in her work, using the cat as a conduit—as explored in her late 1940's series *Le Chemin des chats (The Way of Cats)*.

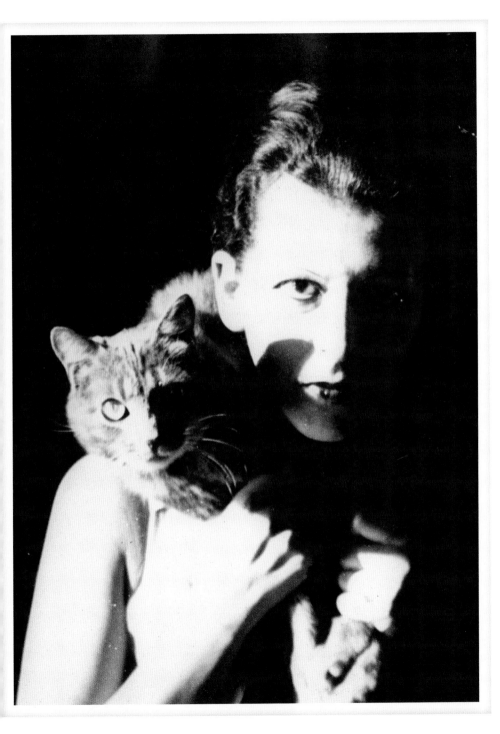

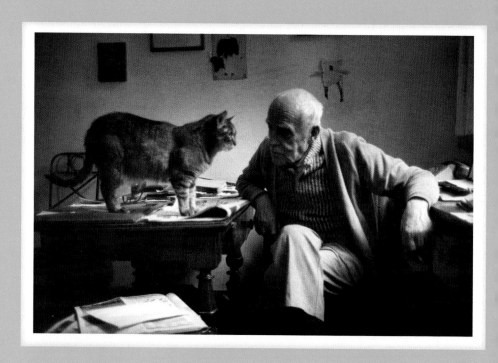

DIEGO GIACOMETTI

All three of the Giacometti brothers were artists. Alberto, a sculptor and painter, is best known for his attenuated figures that stand at attention; Bruno was a notable architect; and the last of the trio, Diego, was a celebrated sculptor who possessed an affinity for animals. The boys grew up surrounded by the barnyard beasts of their Swiss village near the Italian border. Animals feature as mythological symbols in Diego's work—which, of course, included cats. Diego shared a studio with Alberto in Paris until the end of their lives. Diego's love of his feline companions even influenced his brother's work. Although most recognized for his depictions of human figures, Alberto created several animal sculptures. "I'd seen that cat of Diego's so often coming across the bedroom toward my bed in the morning before I got up that I had it in my mind exactly as it is," Alberto told his biographer, James Lord. "All I had to do was to make it. But only the head can even pretend to be a likeness, because I always saw it head on, coming toward my bed." He also described the lithe creature as a "ray of light," after watching it navigate objects without ever touching them. Thus, Alberto's elongated bronze sculpture from 1954, *The Cat*, was born. The Giacometti brothers' respective bodies of work shared remarkable stylistic parallels, but Diego's passion for creatures great and small, and his refined technique, became a hallmark of his oeuvre.

EDWARD GOREY

With a penchant for grim and ghastly characters, Edward Gorey's mischievously macabre illustrations have transported readers to mysterious costume balls, shadowy theater stages, and eccentric Edwardian tea parties. His inimitable pen-and-ink drawings helped to bring the works of famous authors to life, including Bram Stoker, H. G. Wells, and T. S. Eliot. The animated opening and closing title sequences for the PBS television series *Mystery!* are based on Gorey's artworks, and his popular alphabet book, *The Gashlycrumb Tinies*, is equally whimsical and weird. But it's Gorey's drawings of cats—plump, lavishly bewhiskered felines that wore ballet slippers (Gorey religiously attended the New York City Ballet), lounged on stacks of books (one of his great loves), and delighted in a bit of impish fun—that continue to enchant fans of all ages. The artist also surrounded himself with cats in his personal life, which seem to have been as adorably quirky as their owner's art: One was crippled but loved to perch on his shoulder, another didn't learn to purr until she was ten years old, and all of them liked to drape themselves across his drawing board. Gorey's historic house on Cape Cod has been turned into a museum to preserve the legacy of his work, commemorating his devotion to animals and their welfare.

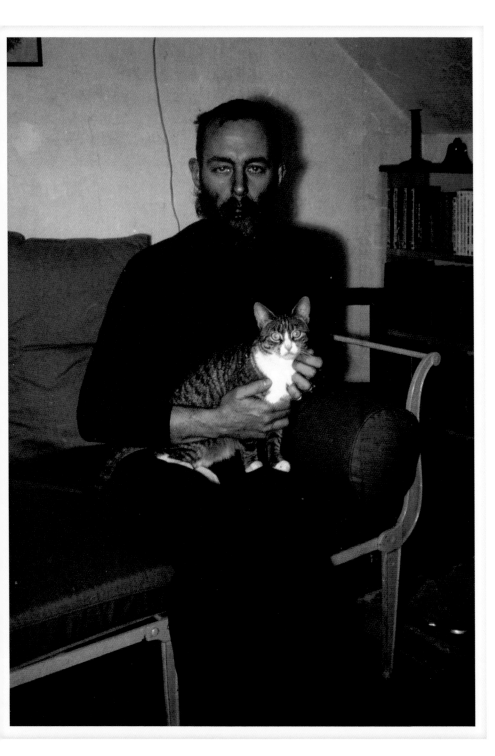

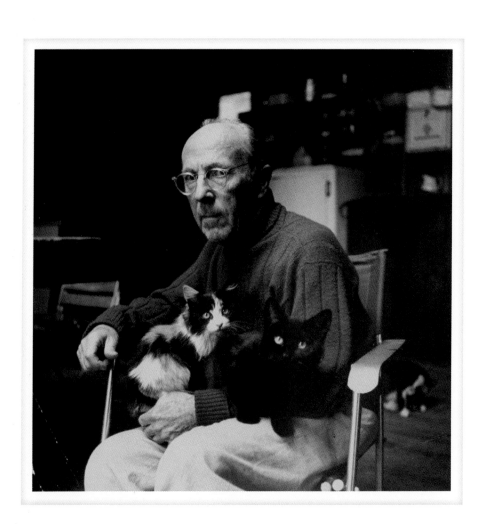

EDWARD WESTON

Edward Weston has been called the most influential American photographer of the twentieth century, and his diverse subjects included nudes, the California landscape, and genre scenes. Weston was also the first photographer to receive the prestigious Guggenheim Fellowship. Later in life, the artist settled into his Carmel Highlands home, near the Point Lobos State Reserve and Big Sur coastline. The property was nicknamed Wildcat Hill, due to the number of cats roaming the grounds. Weston's many pets appeared in a 1947 book the artist created with his wife, Charis, called *The Cats of Wildcat Hill*.

ENKI BILAL

One of France's foremost comic book artists since the 1970s, Enki Bilal—whose surreal stories often incorporate actual historic events—has long been preoccupied with the links between humans and animals. A telepathic, alien cat fuels the science fiction world in Bilal's *Nikopol Trilogy*.

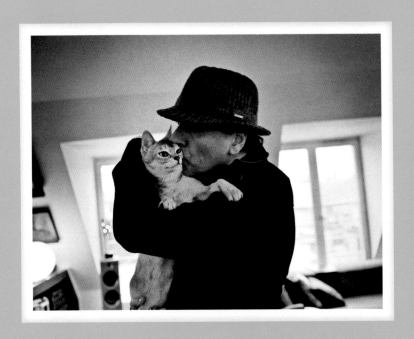

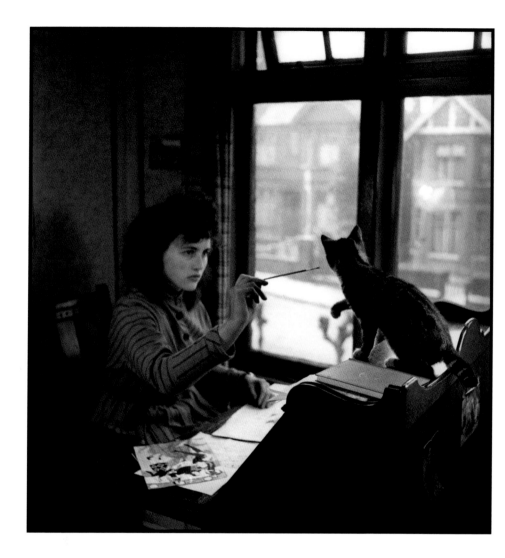

ERICA MACDONALD

Twentieth-century illustrator Erica Macdonald had a little help from a curious cat when crafting her creations. Photographer John Gay captured this charming photo of Macdonald for a feature in the 1947 edition of *Strand Magazine* about up-and-coming female illustrators.

FLORENCE HENRI

During the early twentieth century, avant-garde photographer Florence Henri
hung out with the futurists in Rome and joined the Parisian artistic elite. Later,
she premiered experimental techniques that sometimes found her compared
to famous male contemporaries (Man Ray, László Moholy-Nagy, and Adolph de
Meyer). The artist has since been recognized as one of the leading talents of her
time. Thankfully, she doted on a few cats along the way.

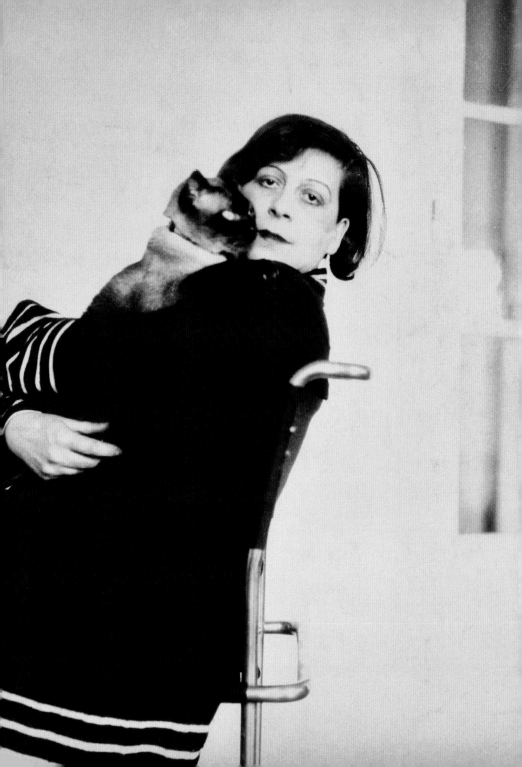

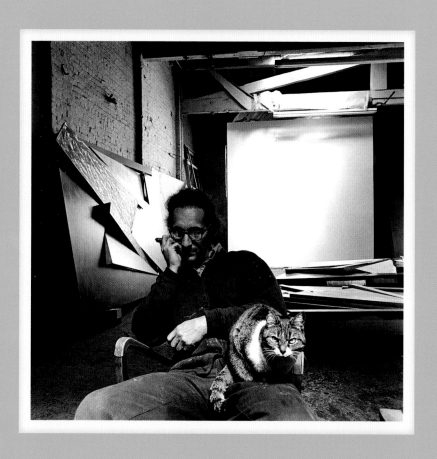

FRANK STELLA

The fiercely independent feline seems like an appropriate pet for Frank Stella, minimalist master of twentieth-century painting. His monumental artworks bear no resemblance to the sovereign beasts, but sometimes slyly reference them—as in the case of his 1984 work on paper, *Then came a dog and bit the cat.*

FRIDA KAHLO

Celebrated painter Frida Kahlo maintained an exotic menagerie of pets at her Mexico City home known as the Blue House (*La Casa Azul*), which included monkeys, a deer, birds, hairless dogs, and cats. Being the mini-megalomaniacs that they are, it's no wonder the feline in this photo looks shunned as Kahlo snuggles a monkey. These eclectic muses roamed freely and made appearances in dozens of her paintings as protective symbols.

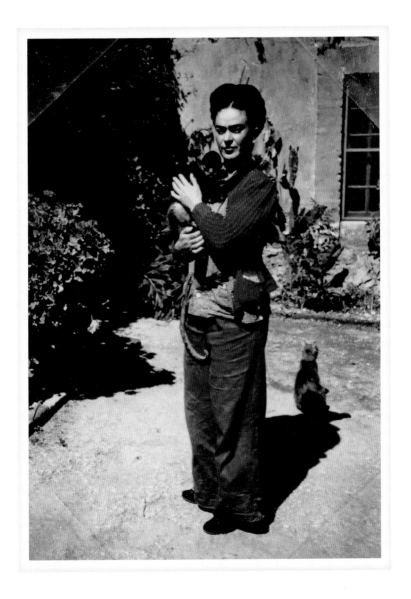

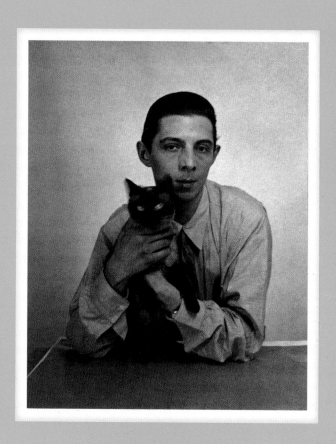

GEORGES MALKINE

A prolific painter who completed nearly 500 works in his lifetime, Georges Malkine was a deeply private man whose creations were initially shown to an intimate audience of collectors and friends. The lone painter to sign André Breton's 1924 *Manifesto of Surrealism* (Breton championed the artist's extreme individualism), Malkine eventually made his way in front of the camera for a rare portrait taken by Man Ray, the darling of the Dada and surrealist set. The solitary cat seems like a kindred spirit befitting the companionship of the quietly rebellious artist.

GEORGIA O'KEEFFE

Hailed as the "Mother of American Modernism," painter Georgia O'Keeffe was frequently inspired by the rugged mountains and deserts surrounding her New Mexico home, which she shared with numerous pets. It was there that she first met John Candelario, a seventh-generation New Mexican and aspiring photographer. O'Keeffe became an early mentor to Candelario, who took her photo on several occasions—including this charming image of the artist with her Siamese cat. She eventually showed his portfolio to her husband, art promoter Alfred Stieglitz, who exhibited his work at the Museum of Modern Art. Candelario later became a master photographer, known for his platinum prints and scenes depicting his native state.

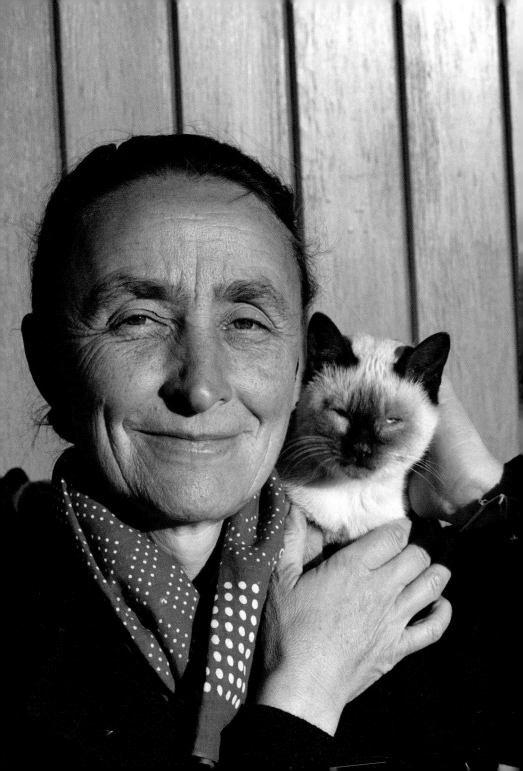

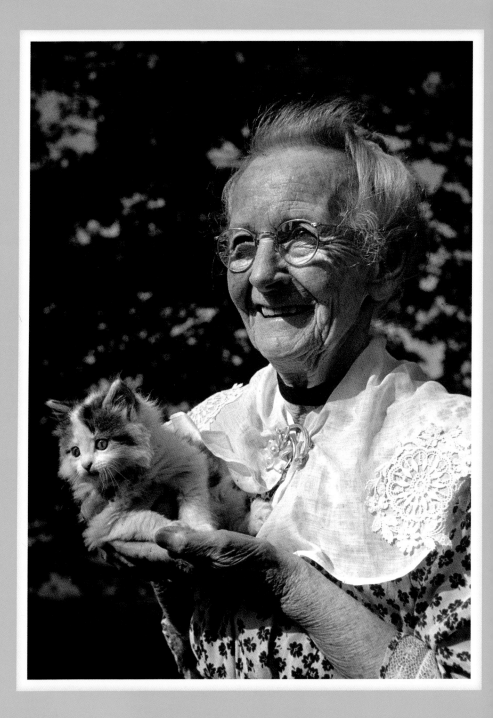

GRANDMA MOSES

The bucolic life of a farm cat sounds like a feline paradise—there are plenty of animals to keep company, open fields to explore, and tasty critters to hunt. A few barn kitties were lucky enough to be immortalized in the renowned folk paintings of Grandma Moses (born Anna Mary Robertson), who continued to work on a farm into her seventies. The paintings depict homely scenes of rural life, which include the many animals that gathered at her agricultural homestead.

GUSTAV KLIMT

Austrian symbolist Gustav Klimt's studio was always filled with women and cats. Klimt's sensual, opulent paintings of his elaborately coiffed muses didn't overshadow his love for felines—one of which he simply named Katze (German for "cat"). One of his models, Friederike Maria Beer-Monti, even described the artist as "animal-like."

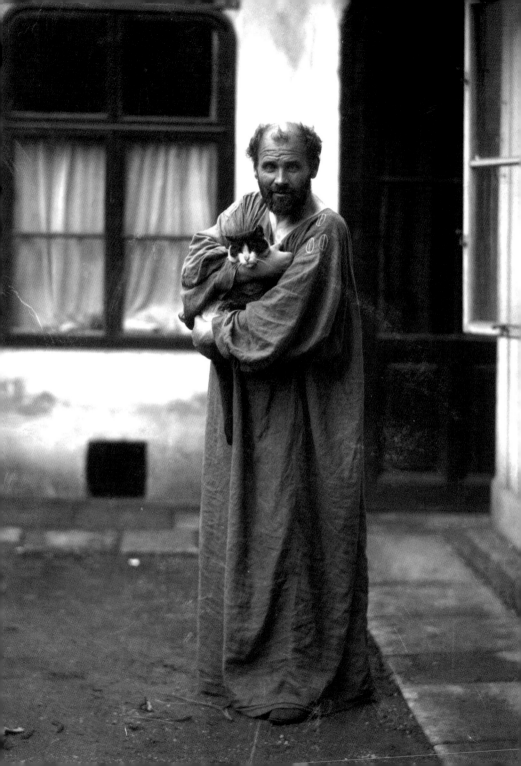

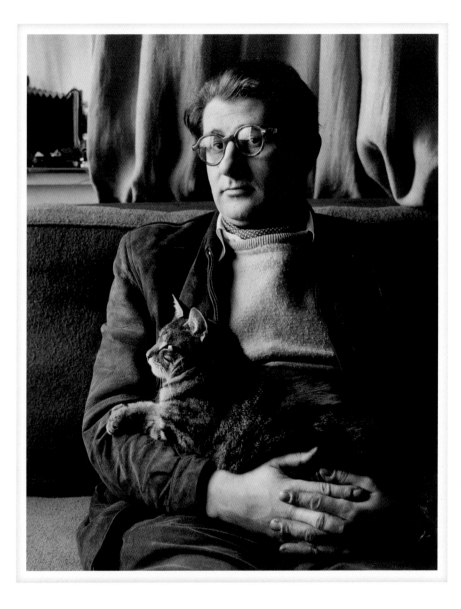

HELMUT NEWTON

Photographer and consummate provocateur Helmut Newton sometimes imbued his fashionable, erotic images with a sardonic, sly sense of humor. The artist's roguish swagger is captured in this portrait with a contented lap cat, taken by Australian photographer Athol Shmith in 1957.

HENRI CARTIER-BRESSON
and MARTINE FRANCK

The "Father of Photojournalism," who spent more than three decades chronicling some of the greatest moments of the twentieth century for *Life*, Henri Cartier-Bresson was a deeply private man who rarely allowed himself to be photographed. He was, however, very forthcoming about his love for cats. "I'm an anarchist, yes," he explained in a 2003 interview for *Vanity Fair*. "Because I'm alive. Life is a provocation. . . . I'm against people in power and what that imposes upon them. Anglo-Saxons have to learn what anarchism is. For them, it's violence. A cat knows what anarchy is. Ask a cat. A cat understands. They're against discipline and authority. A dog is trained to obey. Cats can't be. Cats bring on chaos." Cartier-Bresson's wife, Martine Franck, was a celebrated photographer in her own right. She captured some of the greatest minds and talents of the twentieth century, including philosopher Michel Foucault and painter Marc Chagall. Franck is also known for her documentary photos of remote communities, her tenure as official photographer for Parisian avant-garde ensemble Théâtre du Soleil, and membership with Magnum Photos (cofounded by Cartier-Bresson). Cartier-Bresson's 1989 portrait of their cat Ulysses, pictured with Franck's striking shadow, shows the artists' "anarchic" beast in repose.

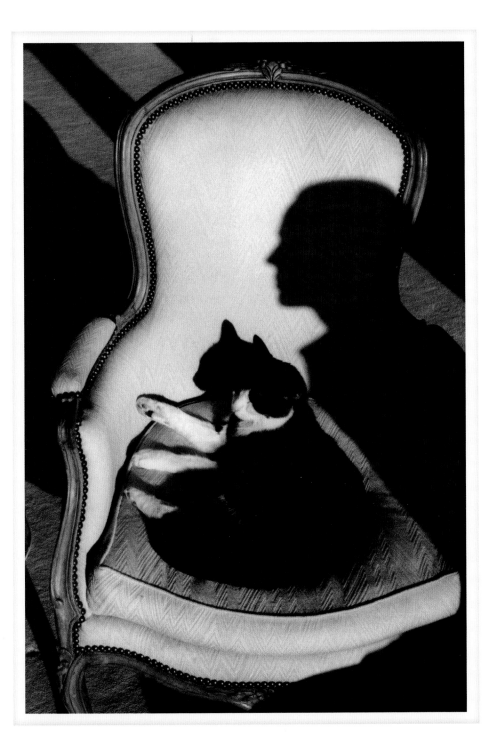

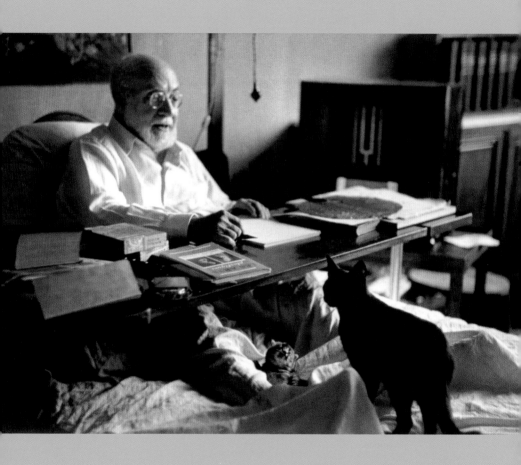

HENRI MATISSE

It seems fitting that the artist who broke the established rules of painting and helped shape the look of modernity had a fondness for the independent cat. Matisse's contemporaries didn't always embrace his audacity with color and simplicity of form, but the artist's work feels very relevant in our world. Just after the turn of the twentieth century, Matisse created a series of "Girl with" and "Women with" paintings that not only pushed the boundaries of portraiture and color, but also revealed a very modern sensibility. His feminine figures exude empowering traits: confidence, self-determination, and unpretentiousness. Naturally, a cat took center stage for one of these bold works: *Girl with a Black Cat*, for which Matisse's daughter Marguerite posed—her eyes perhaps more feline than the black mass resting in her lap. Matisse kept several cats as pets during his lifetime. The cherished companions joined him on every step of his artistic journey. There was Coussi, a large, striped cat, and her sister la Puce (the "flea"), a sleek, black kitty. Minouche was the siblings' mother, a petite, white and gray cat. Animals soothed Matisse's soul. The quiet, serious revolutionary seemed to melt when his feline companions were underfoot. Near the end of his life, Matisse's pets accompanied him to his apartment at the Hotel Regina in Nice, a suite formerly used by royalty, where he worked from bed on his designs for the Chapelle du Rosaire (Chapel of the Rosary) in Vence, which he considered his masterpiece.

HERBERT TOBIAS

German photographer Herbert Tobias is fondly remembered for his striking black-and-white portraits of famous personalities, including disco icon and Salvador Dalí muse Amanda Lear (in one image, clutching his pet cat to her chest), actor Klaus Kinski, and singer-songwriter Nico (the artist discovered the former Warhol Superstar when she was only sixteen and is credited with giving her the nickname). Fittingly, for an artist of his monochromatic palette, he owned a magnificent black cat. Art collector Pali Meller Marcovicz once said that Tobias was "an outsider not fitting in any standard," which made him a fierce feline ally.

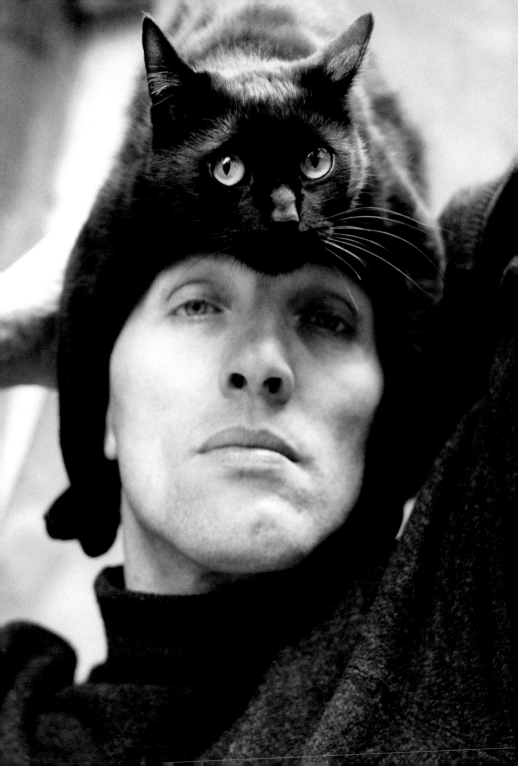

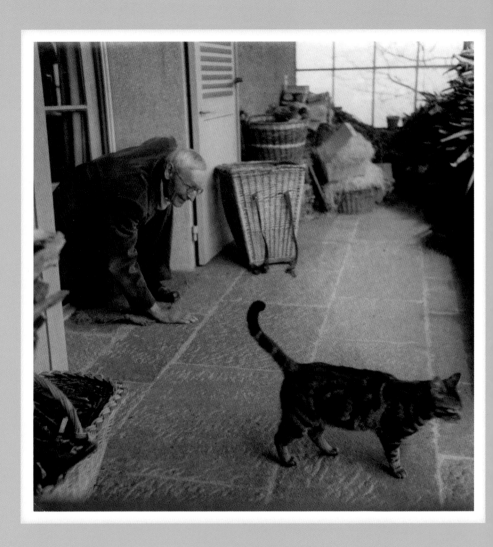

HERMANN HESSE

Hermann Hesse is most widely recognized for his story about a young man on a spiritual journey, *Siddhartha*, and his semiautobiographical novel, *Steppenwolf.* A lesser-known aspect of the German novelist's career is his output as a painter. He didn't pick up a brush until his forties, but produced a significant body of work. Just as his writings examined the path of self-discovery, Hesse's self-portraits and dream paintings (encouraged by his therapist) guided him through an existential crisis. Hesse's pet cats also offered him solace from his introspective spells. In his many letters, the author often shared stories about the cats crowding the Hesse household—including the archetypally named Lion and Tiger.

JACQUES VILLON,
MARCEL DUCHAMP,
RAYMOND DUCHAMP-VILLON

The Duchamp brothers—Jacques Villon (born Gaston Émile Duchamp), Marcel Duchamp, and Raymond Duchamp-Villon—were all successful artists with triple the affection for cats. The siblings could often be found communing in the garden of Jacques Villon's studio in Puteaux, France, with Jacques's dog, Pipe, and other assorted Duchampian critters. The trio founded a collective known as the Puteaux Group or Section d'Or (Golden Section), which was a collective of artists associated with orphic cubism.

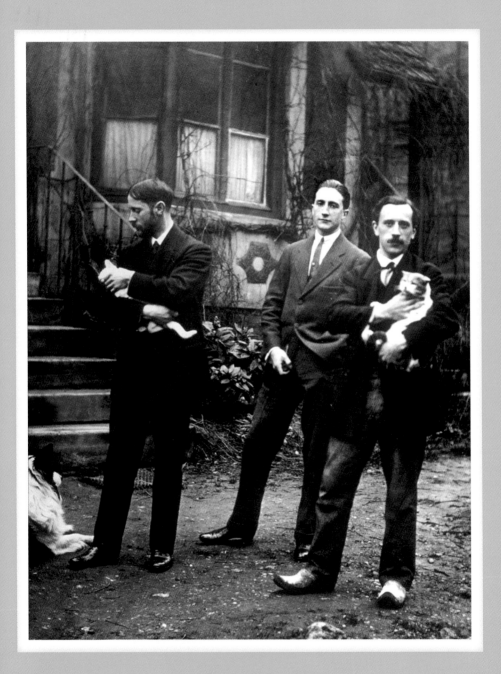

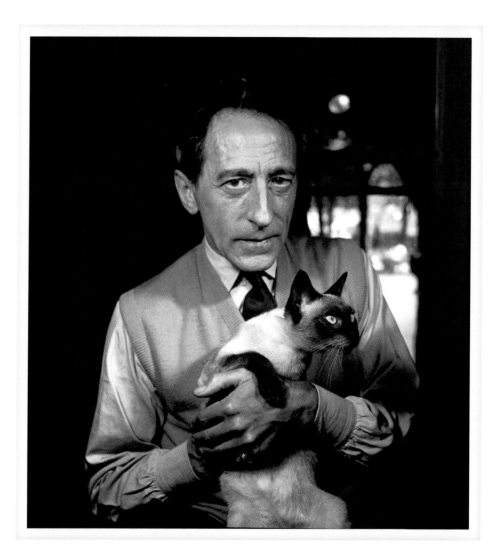

JEAN COCTEAU

The Observer's notable portrait photographer Jane Bown captured a charming image of French artist Jean Cocteau in 1950, accompanied by his beautiful Siamese cat, Madeleine. Cocteau was overjoyed with the results and penned a letter to Bown, sharing his, and Madeleine's, gratitude: "Rare are they who think of those whose images they carry away. And so I am very grateful to you. All the proofs are magnificent. Madeleine is in ecstasy over the Siamese cat. All the household embraces you." Cats often found their way into Cocteau's whimsical drawings. He considered them the "visible soul" of his home. Eventually he took his devotion a step further by founding the Cat Friends Club in Paris, which sponsored international cat shows, and designing their membership pin, a cartoonish cat head.

JEAN-MICHEL BASQUIAT

In 1982, Jean-Michel Basquiat sat to have his portrait taken in the studio of esteemed Harlem Renaissance photographer James Van Der Zee. Basquiat was only twenty-one years old at the time, but had already captured the attention of the art world after making his mark as a graffiti artist using the tag SAMO ("Same Old Shit") and his participation in the 1980 Times Square Show. The photographer was in his nineties, but his career was enjoying a late resurgence during the period. The resulting photos from the session, one of which included a Siamese cat belonging to Van Der Zee's wife, Donna, were commissioned by curator and Mudd Club co-owner Diego Cortez. Basquiat practically lived at Cortez's nightclub, which became a venue for his band Gray. The images accompanied curator and critic Henry Geldzahler's conversation with the artist in Andy Warhol's *Interview* magazine:

> Geldzahler: What do you think of James Van Der Zee?
> Basquiat: Oh, he was really great. He has a great sense of the "good" picture.
> Geldzahler: What kind of a camera did he use?
> Basquiat: Old box camera that had a little black lens cap on the front that he'd take off to make the exposure, then put it back on.

Wearing one of his signature suits with paint-splattered pants, this neoromantic image of the sullen, enthroned artist is a subversive twist on the nineteenth-century wave of exoticism that pervaded the decorative arts. This is emphasized further by the appearance of the sulky cat, also representative of Basquiat's entry into the predominately white art world—an establishment many would come to accuse of exploiting him as an exotic figure. Van Der Zee's photo shows Basquiat snubbing commercializing institutions while also mischievously satirizing his own desire for fame—a subject he often considered in his own paintings. According to Donna Van Der Zee, who inspired the photographer's late-peak renaissance, the portrait was Basquiat's favorite personal photo. Basquiat later showed his affection for the famed photographer, who subverted notions of African Americans with his dignified portraits of the Harlem Renaissance, in the painting *VNDRZ*.

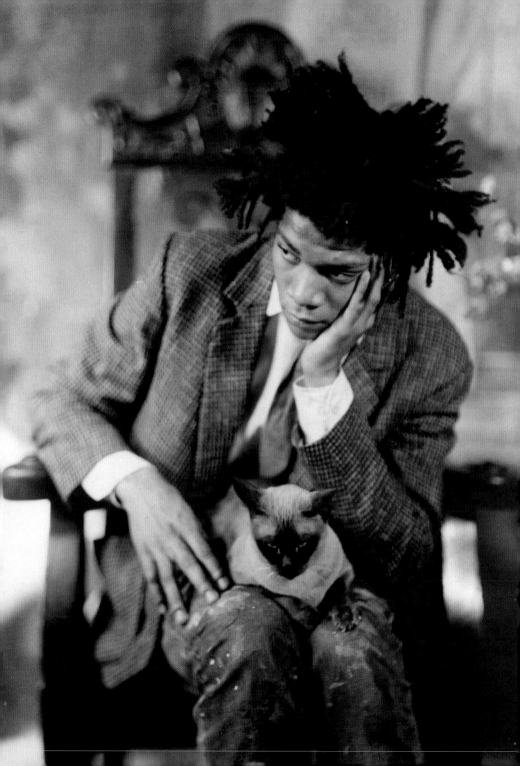

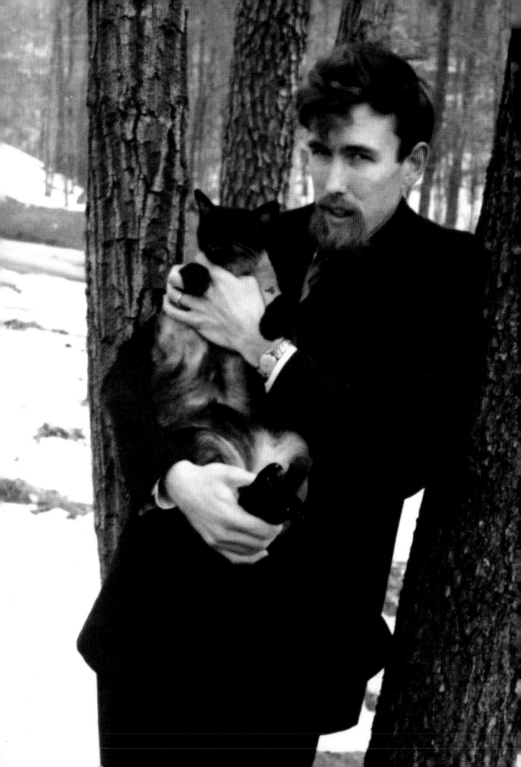

JIM HENSON

Muppets maestro Jim Henson had a talent for creating compelling characters loved by children of all ages. The soft-spoken artist had one foot in the show biz world and the other in the realm of the counterculture. He studied painting in Europe and debuted his surreal, experimental 1965 short film, *Time Piece*, at the Museum of Modern Art. Henson's philosophy of love, peace, and tolerance was aligned with the spirit of the 1960s, and the gentle creator also opened his heart to the animal kingdom—as evidenced by his wonderful puppets and the number of pets in his home. George Washington, Henson's Siamese kitty, joined the artist when he married fellow puppeteer Jane Nebel—who brought her own cat, Beauty, into the marriage. George kept Henson company at the Bethesda, Maryland, home studio while he dreamt up new concepts for his clever characters. Jane created a series of drawings of George (and one of George with Jim) during the early days of their marriage. At one point, the Henson clan had eight cats—honored in a painting by then teenage daughter Lisa Henson—including Snowy (short for the adorable Snowy-Feets), Prissy, Woody (named after director Woody Allen), Dorothy, and Kitty.

JOHN CAGE

Cats have come to symbolize individualism, so who better to call a feline a friend than an artist with one of the quirkiest minds of the twentieth century? John Cage's penchant for randomness seemed to fuel his personal interests. He was an amateur mycologist, an avid chess player (Marcel Duchamp taught him the game), and he often cast the I Ching to determine the direction of his work. Cage began his artistic career as a painter, but migrated to music, becoming one of the most influential composers of all time. He did, however, continue creating works on paper and studied printmaking—often using the same chance methods that he applied to his music. Cage was also deeply devoted to the feline members of his household, shared with partner, collaborator, and fellow cat lover, the avant-garde dancer/choreographer, Merce Cunningham. Skookum was a petite, demure black cat who used up more than a few of her nine lives during her time. She once made a meal out of a near-deadly strand of dental floss and eventually departed Cage's home after being accidentally set loose by a handyman. Losa, a black, scruffy former stray, was Skookum's opposite and simply adored being the center of attention. Whenever the cameras were present, there was Losa ready to pounce and play (often biting John and Merce's ankles). Losa's favorite game involved a cardboard box, which an amused Cage would place over the cat and watch him navigate the loft like a strange cartoon character. It earned the boisterous feline the nickname "Losa Rinpoche Taxi Cab." According to Laura Kuhn, executive director of the John Cage Trust, Losa lived to a ripe old age (outliving Cage, even), proving that you just can't keep a good cat down.

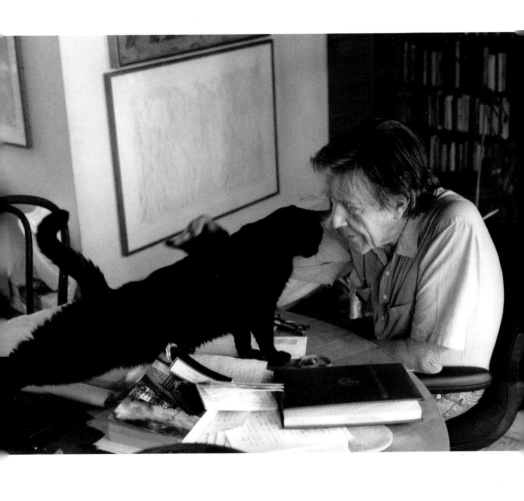

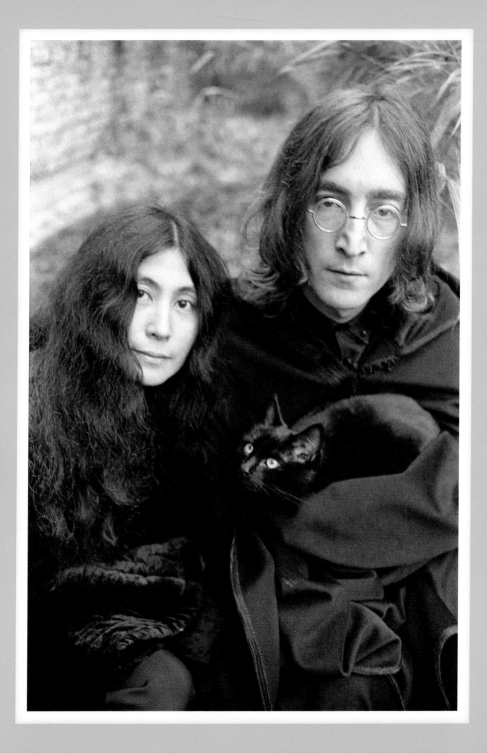

JOHN LENNON *and* YOKO ONO

He's renowned as a music legend, but John Lennon also had a love for literature and visual art. The Beatle-to-be studied at the Liverpool College of Art and was encouraged to pursue drawing and painting by his uncle, George Smith. Sensitive and soulful, Lennon's personality made him a natural cat companion. The fabled artist's special affinity for felines began in his youth. He would ride his bicycle to a Woolton fishmonger every day to lavish his pets with hake. Lennon frequently drew cats, several of which appear in his book of nonsense stories, poetry, and artworks, *A Spaniard in the Works*. Further kittenly impressions can be found in the picture book filled with drawings he made for his son Sean called *Real Love: The Drawings for Sean*. When Lennon met his second wife, avant-garde performance artist Yoko Ono, the couple collaborated on a number of works—most famously, their series of experimental protests, the Bed-In performances. They also shared a fondness for cats. Some of the kitties that stole Lennon's heart include Tich, Tim (a former stray found in the snow), Sam, Mimi (named after his aunt), Babaghi, and Jesus (the name was a tongue-in-cheek response to the media frenzy ignited by Lennon's controversial comment that the Beatles were "more popular than Jesus"), Major and Minor, and Elvis (his very first cat, later discovered to be female). The Lennon and Ono menagerie included Shasha and Micha (two beautiful Persian cats), Alice (sadly, she jumped out of an open window in Lennon and Ono's high-rise apartment at the Dakota in New York City), and Charo ("You've got a funny face, Charo!" Lennon liked to say to her). Two absurdly named cats, a white kitty called Pepper and a black cat named Salt, were proof of the artists' mischievous penchant for defying convention.

LOUIS WAIN

Victorian-era illustrator of cats Louis Wain is known for his anthropomorphic, and later kaleidoscopic (read: shockingly psychedelic), felines. The artist's whimsical cat portraits were conceived as a project to comfort his dying wife, Emily Richardson, who adored the family kitty, Peter. "To him, properly, belongs the foundation of my career, the developments of my initial efforts, and the establishing of my work," he once said of the cherished pet. Wain's artworks became increasingly bizarre as his mental health declined (caused, many speculate, by the onset of schizophrenia, triggered by toxoplasmosis), eventually leading to his institutionalization. Prancing and delighting in cartoonish antics, the lighthearted cats of the artist's earlier work became beastly and almost unrecognizable as he approached the twilight of his career. Nonetheless, Wain's affections for felines forged a legacy, which is still tangible today. As a former chairman and the cofounder of the UK's National Cat Club (for which he designed the logo), Wain is widely credited for establishing the public's love for cats as household pets.

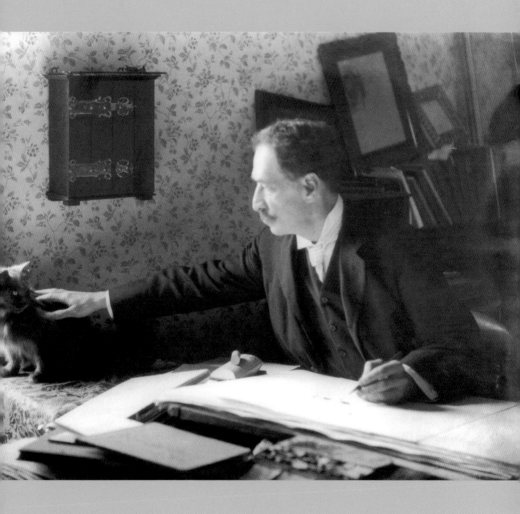

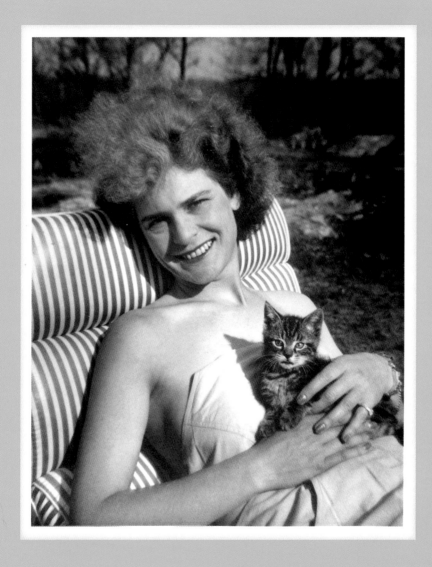

MARGARET BOURKE-WHITE

Pioneering documentary photographer Margaret Bourke-White became the
first female war correspondent and one of the first staff photojournalists for
Life (her image of the Fort Peck Dam in Montana graced the first cover of the
magazine in 1936). Like many trailblazing individuals, she was an evident cat
fancier, frequently photographed fawning over her pets throughout the years.

MAYA LIN

Michael Katakis photographed landscape artist and prominent architect Maya Lin, most famous for her unconventional and solemn design for the Vietnam Veterans Memorial in Washington, D.C., while she shared a quiet moment with her cat in her New York City studio. Lin grew up in southeastern Ohio and felt bonded to animals at a young age. She spent countless hours alone, feeding the tiny backyard beasts that visited her daily. "I wanted to be an animal behaviorist. I wanted to be a vet. I wanted everything to do with nonhuman species. And even to this day, I've been very interested in science. The other side of me was art," she once related in an interview with PBS. Lin's 2012 project, *What is Missing?*, is an interactive website featuring audio recordings, photos, and texts that act as a memorial for lost and endangered species.

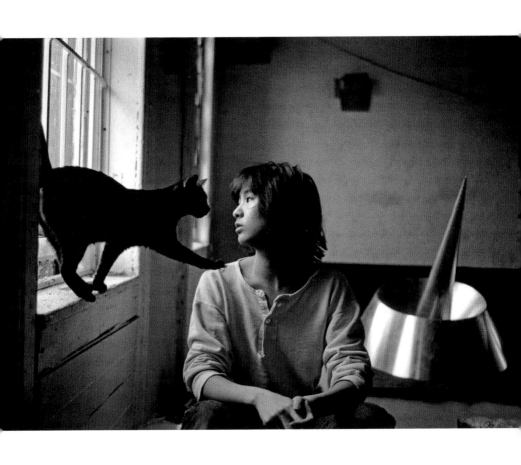

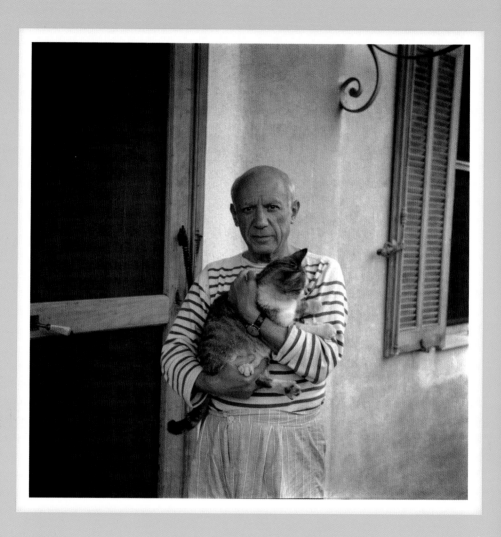

PABLO PICASSO

Praised for his deftly painted scenes of brutality and passion—words that could also describe his personal life and relationships—Picasso's tenderness was elicited by the animal kingdom. Cats were as much of a part of the twentieth-century master's artistic oeuvre as the women he obsessively rendered, appearing in paintings and drawings throughout his extraordinary career. Living in the Le Bateau-Lavoir commune in the Montmartre district of Paris between 1904 and 1909 (where he created one of his most famous works, *Les Demoiselles d'Avignon*), the young painter befriended a Siamese cat he found roaming the streets and named it Minou (French for "kitty"). Later, in his seventies, Picasso was photographed with a tabby cat (to match his striped shirt) by fauvist painter Carlos Nadal at the maestro's house in Vallauris, France, in 1954. Nadal observed that the cat never left Picasso's lap.

PATTI SMITH

Patti Smith's involvement in the New York art scene during the late 1960s and '70s is the stuff of legend. She left her studies at a teaching college in New Jersey and a factory job in Philadelphia behind, entering the city with only a few art supplies and mere dollars in her pocket. A chance meeting with then unknown photographer Robert Mapplethorpe started an incredible chapter in her life. The lovers and eternal soul mates struggled and sacrificed so they could create their art (during this period, they were preoccupied with drawing). Later in their relationship, they came into contact with a whole new world of artists, provocateurs, and fellow misfits when they moved into room 1017 at the Chelsea Hotel. Smith traded her portfolio as collateral for rent and found herself among the likes of underground icons Janis Joplin, Harry Everett Smith, William S. Burroughs, Allen Ginsberg, and Gregory Corso. The "Godmother of Punk" continues to blur genres and art forms with her drawings, photographs, prose, and music. In 2010, Smith received an honorary doctorate in fine arts from the Pratt Institute, the campus she frequented after her New York pilgrimage, where Robert and other friends went to school. Many cats have acted as Smith's guardians during her rise to fame, and the artist's meowing muses have appeared in several of her pictures. Any number of interviews with the artist-performer mentions at least one feline friend in passing. Fine art photographer Frank Stefanko, famous for his portraits of rock royalty (such as Bruce Springsteen, Janis Joplin, and Frank Zappa), captured Smith's emergence into the music world—including this 1974 photo of the singer with a daydreaming black cat. In the 2008 documentary *Patti Smith: Dream of Life*, Smith shares a sweet moment with her marmalade-colored cat by serenading the nuzzling feline with a tender version of Fabrizio De André's "Amore che vieni, amore che vai."

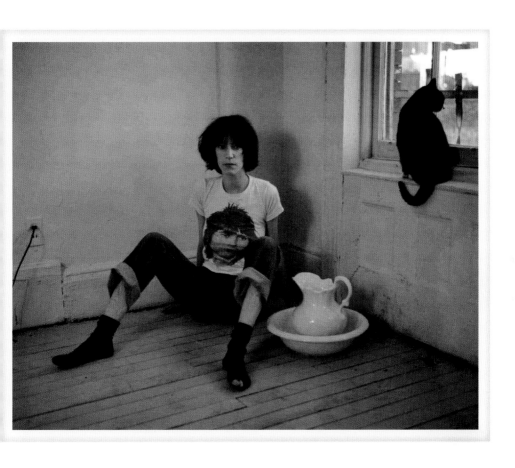

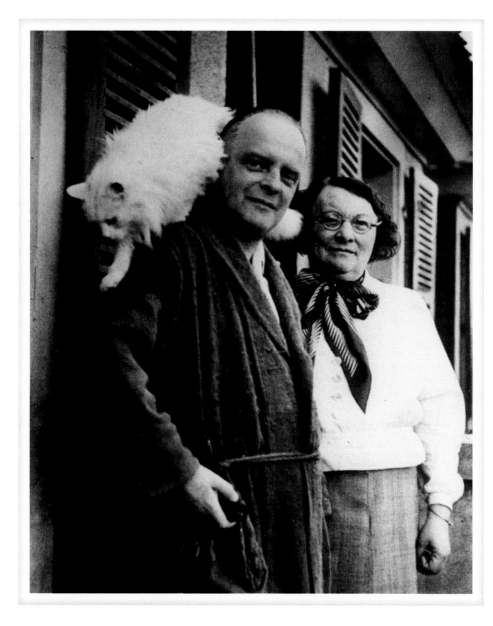

PAUL KLEE *and* LILY STUMPF

A prolific figure in European modernism, Paul Klee's radical ideas were tempered by a witty and playful spontaneity. This is perhaps most evident in his many cat-centric artworks, such as the 1928 oil and ink painting, *Cat and Bird.* The colorful feline is rendered in extreme close-up and gazes hungrily at us while a bird appears as a wishful vision inside its head. Several of Klee's works reference the pets in his life, and he loved to photograph them. His white, long-haired cat named Bimbo, pictured here with Klee's wife, pianist Lily Stumpf, was a loyal companion and makes several appearances in Klee's oeuvre. Other Klee kitties include a dark longhair named Mys, tabby Fritzi, and the longhair kitten he called Nuggi.

PHILIP BURNE-JONES

Philip Burne-Jones was the son of two artists, Sir Edward Burne-Jones, a British Pre-Raphaelite painter, and Georgiana Macdonald. Although often compared to his famous father, he later became a successful painter in his own right. The younger Burne-Jones exhibited at the Royal Academy over the span of twenty years and was also featured in the Paris Salon of 1900 (a painting of his father shown there now hangs in the National Portrait Gallery). He's best remembered for his portraits—Henry James, George Frederic Watts, and Rudyard and Carrie Kipling were a few of his notable sitters—and the 1897 painting, *The Vampire*. The undead woman in the controversial artwork resembled actress Mrs. Patrick Campbell—a former love interest who reportedly dumped him. Morbid revenge paintings aside, the artist still had room in his heart for at least one beautiful cat, as seen here. Early drawings by the elder Burne-Jones depict Philip and the family feline, so Philip's cat love wasn't a complete anomaly. The artist also penned a book containing observations about his yearlong travels around the United States. He created the illustrations, which, sure enough, included a cat dashing along a New York City sidewalk. When describing the "frightful hurry and restless bustle everywhere," he wrote: "The very cats appear *distraites*, and preoccupied, and as though they were late for an appointment. Who ever would stop to say, 'Puss! puss!' to an American cat."

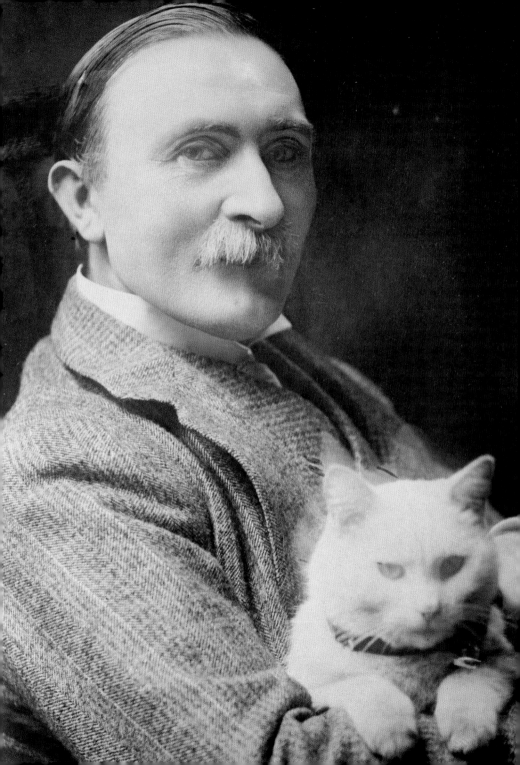

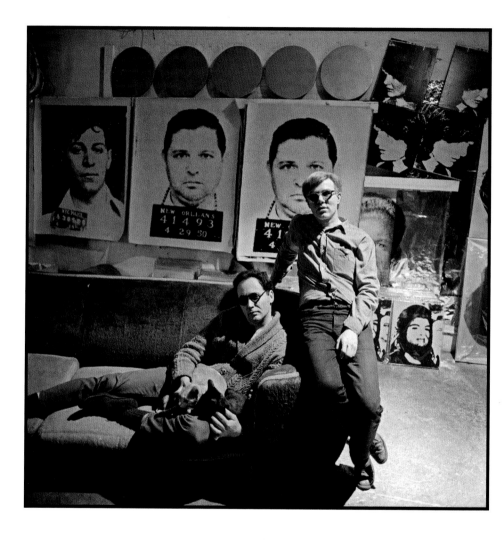

ROBERT INDIANA *and* ANDY WARHOL

One of the pop art movement's most eminent participants Robert Indiana shied away from the parties at Andy Warhol's Factory, distinguishing himself among the elite clique of personalities. Born Robert Clark in New Castle, Indiana (as his adopted surname suggests), the artist was sent to live on a family farm when he was a young boy. He spent a lot of time alone, but befriended several animals— including the resident farm cats. After arriving in New York City during the 1950s, he continued to keep cats as pets. Serendipitously, he met fellow cat lover Andy Warhol at St. Adrian's Bar in the old Broadway Central Hotel several years later. Indiana became the star of Warhol's 1963 film *Eat*, which featured the artist slowly eating a mushroom in his SoHo loft for nearly an hour, edited out of sequence. Clearly seeking a costar billing, Indiana's curious cat enters the scene, settles against his owner's frame, and gazes knowingly at the camera, bringing a huge grin to the artist's face.

ROMARE BEARDEN

Pioneering African American artist, master collagist, and cat lover Romare Bearden was crazy about his kitty, Gippo. The striped feline was quite the looker and never missed a photo op with his owner, who was also famed as a cartoonist and protégé of German artist George Grosz. "Gippo is I think a very handsome cat. He's perfectly symmetrically striped with gray and tan markings," Bearden gushed in a 1968 interview. "We found him in the woods and he has a little wild-cat in him and it took a long time, about six or eight months, when he was a young kitten, to get him trained. But now he's happy. The studio he feels is his."

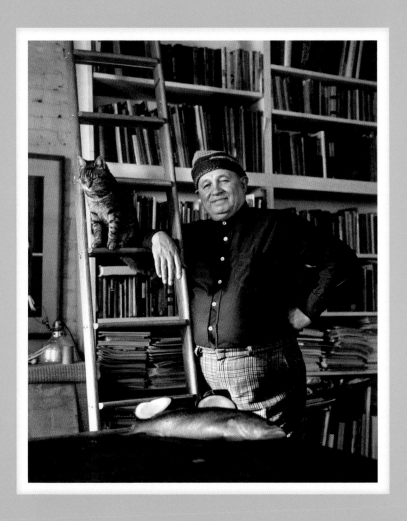

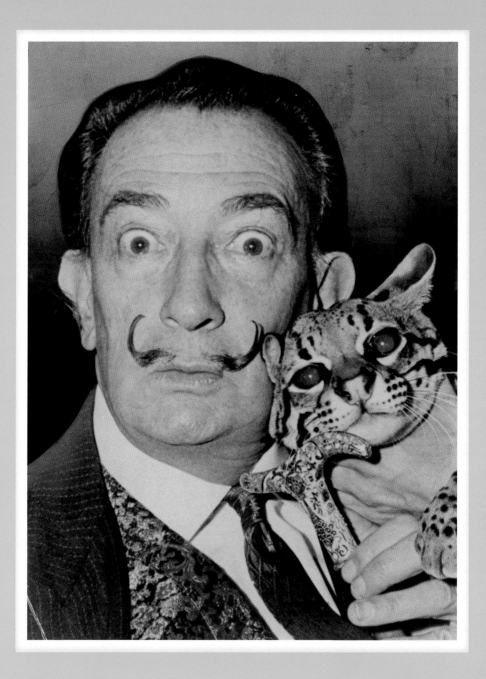

SALVADOR DALÍ

Never content to play by the rules or follow proper behavior as we peons might, eccentric surrealist painter Salvador Dalí kept a Colombian ocelot as a pet. Although overtly resembling a domestic cat, the species is extremely territorial and known to be a fierce fighter. Dalí's treasured ocelot, nicknamed Babou, was treated to the finest life had to offer, including luxury cruises on the *SS France*, bejeweled collars, trips to the top of the Eiffel Tower, and fine dining. Legend has it that Babou accompanied Dalí to a Manhattan restaurant, where the grand cat sat tethered to his table. The exotic feline's presence alarmed a fellow diner, but the outrageous artist reassured her that Babou was a regular cat, painted to imitate its wilder relation. Dalí held court at the elegant St. Regis hotel when he stayed in New York City, where Babou would join him for meetings and autograph signings in the lobby. The spotted cat's favorite place to sleep was an empty television set, but at the Dalí home in Spain, he preferred napping in olive trees. That is, of course, when he wasn't making friends with the local alley cats or tearing his master's socks apart (apparently his favorite pastime).

SAUL STEINBERG

Renowned for his cartoons and artworks that frequently graced the *New Yorker* (including almost ninety covers), Romanian-born American artist Saul Steinberg created hundreds of whimsical, elaborate line drawings of cats. During his illustrious career, Steinberg had an opportunity to pose with a curious kitten for friend and collaborator Henri Cartier-Bresson. Steinberg famously once "authorized" Cartier-Bresson to be a photographer in a falsified, humorous document (oh, those wacky artists), but the cat in Steinberg's snapshot clearly needed no permission to investigate the photo shoot.

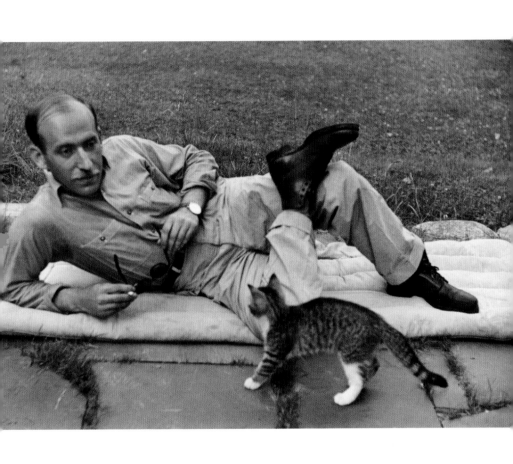

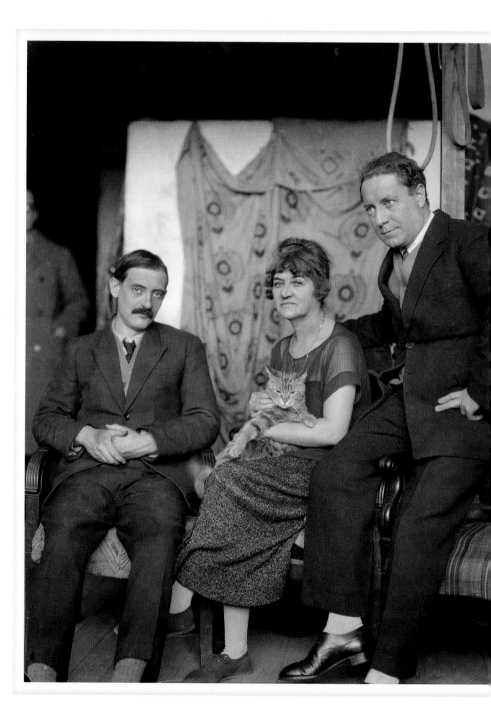

SUZANNE VALADON, MAURICE UTRILLO, ANDRÉ UTTER

Any cat lucky enough to call nineteenth-century French artist Suzanne Valadon a friend was in for an adventure. The first female painter granted acceptance to the Société Nationale des Beaux-Arts, Valadon began her career as a circus acrobat. She became a respected art model, posing for well-known painters such as Toulouse-Lautrec, Renoir, and Pierre-Cécile Puvis de Chavannes, and later married her own sitter, painter André Utter. With encouragement from friends, including Edgar Degas, Valadon began her own foray into the art world. She was known for her female nudes—a subject most women artists eschewed during the period. Her vibrant still lifes, portraits, and interiors often included cats. Several such companions took up residence in her studio over the years. The free-spirited artist used her finest fashions to create beds for them. Her kitties were lavished with beluga caviar on Fridays and kept company by a German sheep dog and goat, which she fed her bad drawings to. Valadon's story is also proof that cat love runs in the family. The bohemian model turned portraitist instilled a fondness for felines in her son, Maurice Utrillo, at a young age. The painter's affinity for cats was matched only by his fame for the atmospheric cityscapes he depicted—mainly the Montmartre quarter during the early twentieth century.

TSUGUHARU FOUJITA

You could do a lot worse in life than to find acclaim for paintings of beautiful women and cats. Tsuguharu Foujita's prints and Japanese-style paintings, which used Western oil techniques (a unique practice among early-twentieth-century painters), were never short on aesthetic appeal. Positioned at the center of Montparnasse's vibrant cultural circle, the Japanese painter drew the attention of leading artists such as Juan Gris, Pablo Picasso, and Henri Matisse. The eccentric painter was an inimitable figure, styling his hair after an Egyptian statue, dressing in tunics, sporting a wristwatch tattoo, and sometimes even wearing a lampshade as a hat. However, the graceful, serpentine lines of Foujita's feline artworks are arguably just as eye-catching.

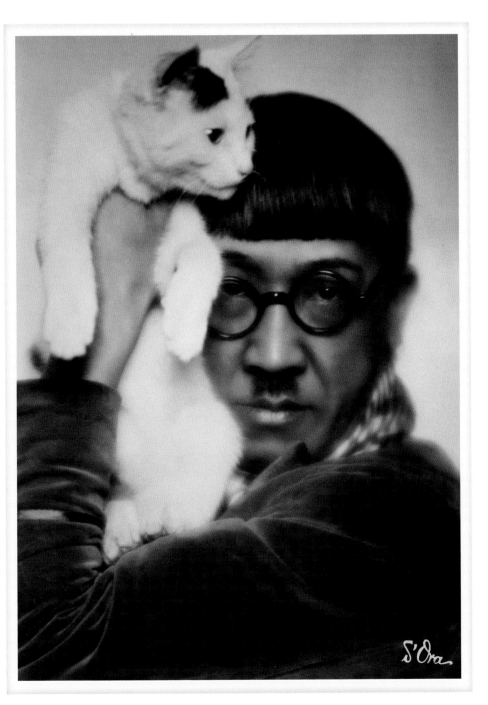

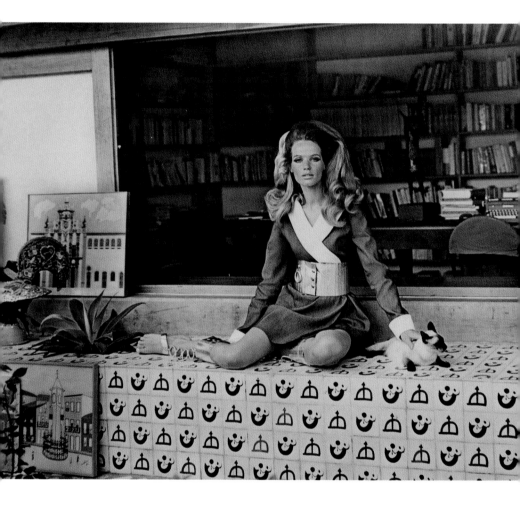

VERUSCHKA

With a reputation as the first supermodel, a pioneering body-painting artist (she once collaborated with Salvador Dalí), and a Hollywood darling, Veruschka embodied slinky sixties sensuality. A five-minute cameo in Michelangelo Antonioni's 1966 film, *Blow-Up*, helped cement her celebrity status, but the German-born countess became a pop culture icon during her tenure with *Vogue*. Her striking name and lithe, feline frame often found her posing in exotic locales, sometimes with exotic animals—as in the case of her now famous 1967 William Klein photoshoot for *Vogue*, costarring a cheetah. After retiring from modeling in 1975, Veruschka began collaborating with artist Holger Trülzsch for a conceptual series of photographic self-portraits that transform her camouflaged, painted body. Veruschka is a known cat lover and has tended to dozens of feral felines in cities across the world.

WANDA GÁG

Wanda Gág's pioneering, folk art–style storybook, *Millions of Cats*, became
a children's classic—notable for being the first book to feature double-page
illustrations. The 1929 Newbery Honor winner centers on an elderly couple
who choose one kitty to love after "hundreds of cats, thousands of cats, millions
and billions and trillions of cats" wind up at their door. Gág spent many hours
in the comfort of kittens after leaving a successful commercial art career in
New York's Greenwich Village (surrounded by famous friends such as Georgia
O'Keeffe) for the solitude of farmhouse art studios in Connecticut and rural
New Jersey.

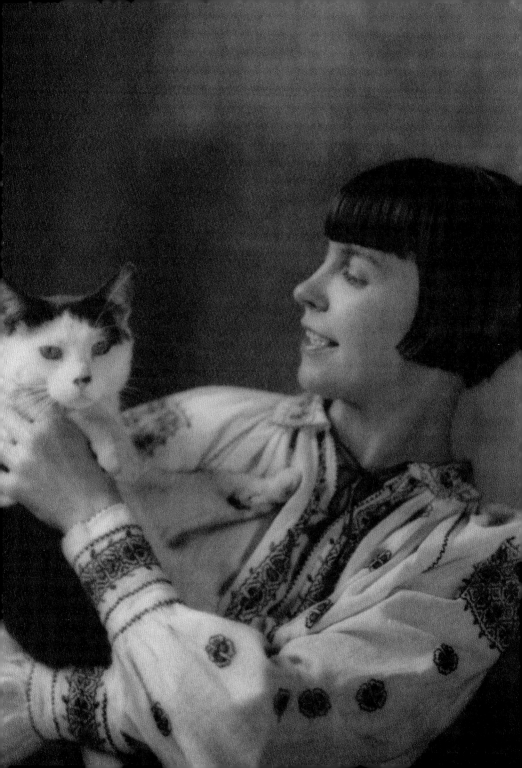

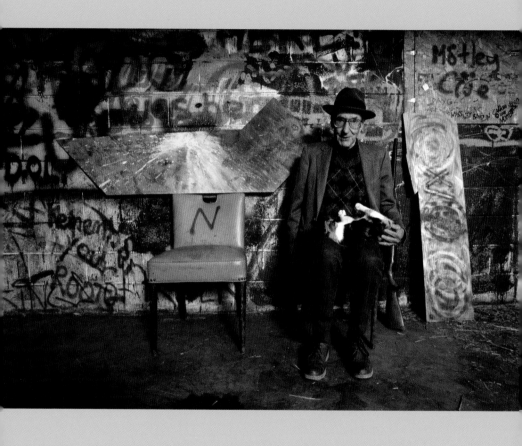

WILLIAM S. BURROUGHS

The misanthropic demeanor and notorious repute of William S. Burroughs seems to have been quelled when confronted with cats. The painter and literary giant viewed them as his "psychic companions." Burroughs's feline epiphany occurred when he moved to Lawrence, Kansas, during the 1980s and settled into a lakefront bungalow. While there, he adopted several strays. Ruski, a handsome Russian blue, was his first. Sweet Ginger was the mother of the orange litter, which included Calico Jane (named after author Jane Bowles). Burroughs had a soft spot for black kitty Fletch, but the cat despised strangers. When Fletch started packing on the pounds, the author compared him to Orson Welles. Doting kitty Spooner followed Burroughs everywhere, and Senshu (a gray tabby girl) and her mother Mutie remained companions for life. Horatio, troublemaker Ed, Wimpy, and countless others were also comrades-in-arms. "I've learned immeasurably. I've learned compassion; I've learned all sorts of things from my cats, 'cos cats reflect you, they really do," Burroughs shared in one of his last interviews. Other confessions of feline vulnerability abound in Burroughs's autobiographical novella, *The Cat Inside*. Just a few days before his death in 1997, Burroughs recorded his final journal entry, which expressed his profound love for his dear cats:

> There is no final enough of wisdom, experience—any fucking thing. No Holy Grail, No Final Satori, no final solution. Just conflict. Only thing can resolve conflict is love, like I felt for Fletch and Ruski, Spooner and Calico. Pure love. What I feel for my cats present and past. Love? What is it? Most natural painkiller what there is. LOVE.

BIBLIOGRAPHY

"Aradia, Or Gospel of the Witches," *Wikipedia*, last modified December 26, 2013. http://en.wikipedia.org/wiki/Aradia,_or_the_Gospel_of_the_Witches.

Bockris, Victor. *Calling Dr. Burroughs—The Last Interview I Will Ever Do.* Thouars, France: Interzone Editions, 2010. www.interpc.fr/mapage/westernlands/dr-burroughs.html.

Bossone, Andrew. "Photos: Queen's Cat Goddess Temple Found in Egypt." *National Geographic Daily News* (January 21, 2010). http://news.nationalgeographic.com/news/2010/01/photogalleries/100121-cat-temple-egypt-pictures/#/bastet-feline-statue-egypt_12139_600x450.jpg.

Brown, Emma, and Henry Geldzahler. "New Again: Jean-Michel Basquiat." *Interview* (January, 1983). www.interviewmagazine.com/art/new-again-jean-michel-basquiat-/#_.

Burne-Jones, Philip. *Dollars and Democracy.* New York: D. Appleton & Company, 1904. http://archive.org/details/dollarsanddemoc00bartgoog.

Burroughs, William S. *Last Words: The Final Journals of William S. Burroughs.* Editor James Grauerholz. New York: Grove Press, 2000. http://books.google.com/books/about/Last_Words.html?id=rbJvbXXvYUgC.

Csikszentmihalyi, Mihaly. "The Creative Personality." *Psychology Today* (July 1, 1996). Excerpt in *Creativity: The Work and Lives of 91 Eminent People*, New York: Harper Collins, 1996. Last reviewed June 13, 2011. www.psychologytoday.com/articles/199607/the-creative-personality.

Eppendorfer, Hans. "Herbert Tobias biography." www.herberttobias.com/bio.html.

Friend, David. "Cartier-Bresson's Decisive Moment." *Digitalist Journalist* (December, 2004). http://digitaljournalist.org/issue0412/friend.html.

Gosling, Samuel D., Carson J. Sandy, and Jeff Potter. "Personalities of Self-Identified 'Dog People' and 'Cat People'." *Anthrozoös* 23, no. 3 (2010): 213–222. doi:10.2752/1753037 10X12750451258850.

"Jane Bown: Eye to Eye," *The Observer, Special Reports,* accessed January 2, 2014. http://observer.theguardian.com/special_report/gallery1/0,,212485,00.html.

"Louis Wain," *Wikipedia,* last modified November 5, 2013. http://en.wikipedia.org/wiki/ Louis_Wain.

Maya Lin, interview with Bill Moyers, *Becoming American: The Chinese Experience,* "Personal Journeys," Public Affairs Television, Inc., 2003. www.pbs.org/becoming american/ap_pjourneys_transcript5.html.

"Miss Amelia Van Buren," *Wikipedia,* last modified December 11, 2012. http://en.wikipedia.org/wiki/Miss_Amelia_Van_Buren.

Ono, Yoko. "The Tea Maker." *The New York Times* (December 7, 2010, accessed April 29, 2014). www.nytimes.com/2010/12/08/opinion/08ono.html.

Rewald, Sabine, and William Slattery Lieberman. *Twentieth Century Modern Masters: The Jacques and Natasha Gelman Collection.* New York: The Metropolitan Museum of Art, 1989. http://books.google.com books?id=0RMoLtRjhggC&printsec=frontcover#v= onepage&q&f=false.

Romare Bearden, interview by Henri Ghent, *Archives of American Art,* Smithsonian Institution, June 29, 1968. www.aaa.si.edu/collections/interviews/oral-history-interview-romare-bearden-11481.

Weiwei, Ai. *Ai Weiwei's Blog: Writings, Interviews, and Digital Rants, 2006–2009.* MIT Press: Cambridge: MIT Press, 2011. http://books.google.com/ books?id=rQbGvUA6XKoC&printsec=frontcover&vq=cats#v=onepage&q=cats&f=false.

CREDITS

Page 57: Henri Cartier-Bresson/Henri Cartier-Bresson/Magnum Photos

Page 58: Henri Matisse/© Robert Capa © International Center of Photography/Magnum Photos

Page 61: Herbert Tobias/Photograph by Peter Fuerst; © 2014 Artists Rights Society (ARS), New York / VG Bild-Kunst, Bonn

Page 62: Herman Hesse/Herman Hesse and cat/Martin Hesse/Suhrkamp Verlag.

Page 65: Villon, Duchamp, Duchamp-Villon/© RA/Lebrecht Music & Arts

Page 66: Jean Cocteau/© Guardian News & Media Ltd 2007

Page 69: Jean-Michel Basquiat/Jean-Michel Basquiat, 1982./ Photograph by James VanDerZee, copyright © Donna Mussenden VanDerZee

Page 70: Jim Henson/Courtesy of The Jim Henson Company Archives

Page 73: John Cage/Courtesy of the John Cage Trust

Page 74: John Lennon/Photo by Ethan Russell ©Yoko Ono

Page 77: Louis Wain/Photo by Ernest H. Mills/Getty Images

Page 78: Margaret Bourke-White/Photo by Alfred Eisenstaedt/Pix Inc./Time & Life Pictures/Getty Images

Page 81: Maya Lin/© Michael Katakis/The British Library

Page 82: Pablo Picasso/Photograph by Carlos Nadal, 1960; © 2014 Estate of Pablo Picasso/ Artists Rights Society (ARS), New York

Page 85: Patti Smith/Photo © Frank Stefanko

Page 86: Paul Klee/Photo: Fee Meisel Zentrum Paul Klee, Bern, Klee Family Donation; used by permission of the Paul Klee Museum

Page 89: Philip Burne-Jones/Photo by Bain News Service, no date listed; image courtesy of the Library of Congress

Page 90: Robert Indiana/© Bruce Davidson/Magnum Photos

Page 93: Romare Bearden/Used by permission from the estate of Romare [now Nanette] Bearden, courtesy of Romare Bearden Foundation, New York; photo courtesy of the National Gallery of Art. Art © Romare Bearden Foundation/Licensed by VAGA, New York, NY

Page 94 and cover: Salvador Dalí/World Telegram & Sun photo by Roger Higgins; image courtesy of the Library of Congress

Page 97: Saul Steinberg/© Henri Cartier-Bresson/Magnum Photos

Page 98: Suzanne Valadon/Photo by Martinie/Roger Viollet/Getty Images

Page 101: Tsuguharu Foujita/© TopFoto / The Image Works

Page 102: Veruschka/Rubartelli/Vogue; © Conde Nast

Page 105: Wanda Gág/Photographer unknown; photo used by permission of the Minnesota Historical Society

Page 106: William S. Burroughs/Photo by Richard Gwin; used with permission

ACKNOWLEDGMENTS

My deepest gratitude to everyone at Chronicle Books, especially Bridget Watson Payne and Caitlin Kirkpatrick. Thanks to Kris Ashley and Jan Hughes for their assistance on this project; Jill Peterson, Cheryl Henson, and Lisa Henson at the Jim Henson Company; Laura Kuhn, director of the John Cage Trust; Agnès Varda and Fanny Lautissier of Ciné-Tamaris; Georges and Michael Matisse, Volker Michels, Rodney Dale, Donna Van Der Zee; and finally, my family for instilling a love and respect for animals (even the human kind).